Welcome to Windsor Castle!

- the oldest and largest castle in the WORLD!
It's been lived in ever since it was built
900 years ago.

Windsor was Queen Elizabeth II's childhood
home and now, as a great-grandmother, she
still spends many weekends here.

The Royal Standard
is The Queen's special
flag. If it's flying –
she's at home!

A Royal Fortress

William the Conqueror (reigned 1066–87) built Windsor Castle after he conquered England at the Battle of Hastings in 1066. It was one of the fortresses he built to keep the English under control.

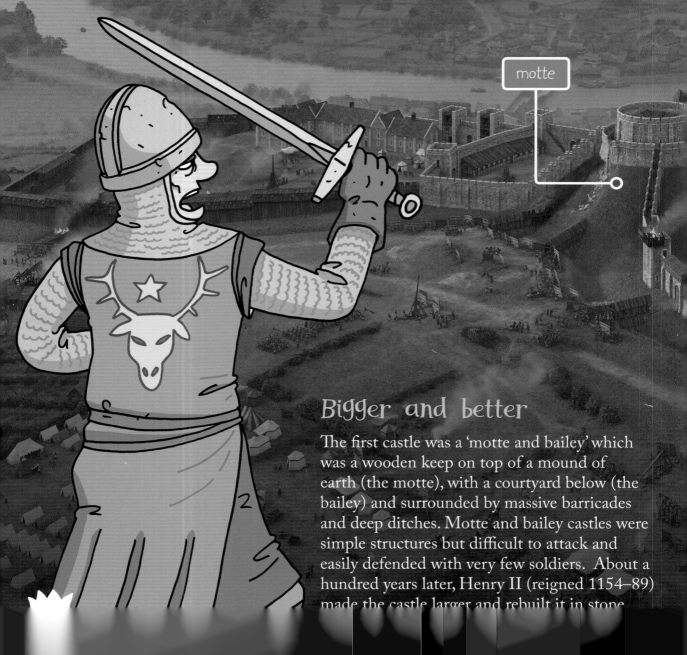

motte

Bigger and better

The first castle was a 'motte and bailey' which was a wooden keep on top of a mound of earth (the motte), with a courtyard below (the bailey) and surrounded by massive barricades and deep ditches. Motte and bailey castles were simple structures but difficult to attack and easily defended with very few soldiers. About a hundred years later, Henry II (reigned 1154–89) made the castle larger and rebuilt it in stone

Besieged!

When King John (reigned 1199–1216) fell out with his powerful barons, they besieged Windsor Castle in 1216. The castle probably looked like this.

River Thames

This escape route (called a sallyport) led to the castle ditch. Defenders could use it to dash out to get help, or to make surprise raids on attackers.

Did you know?
Windsor Castle has only ever been attacked three times – and never captured.

Defending Windsor Castle

Royal castles are protected around the clock. William the Conqueror's soldiers guarded the first castle and later, in the Middle Ages, knights and men-at-arms defended it. Today, the Household Troops keep watch.

Deadly weapons

In the Middle Ages men armed with longbows fired through arrow loops and gaps in the battlements (called crenels) which protected them from enemy fire. Crossbowmen were positioned at important points like snipers. Longbows could shoot further and faster but crossbows were more deadly.

Defenders could drop boulders or boiling water through 'murder holes' on to attackers below.

A soldier aims his crossbow.

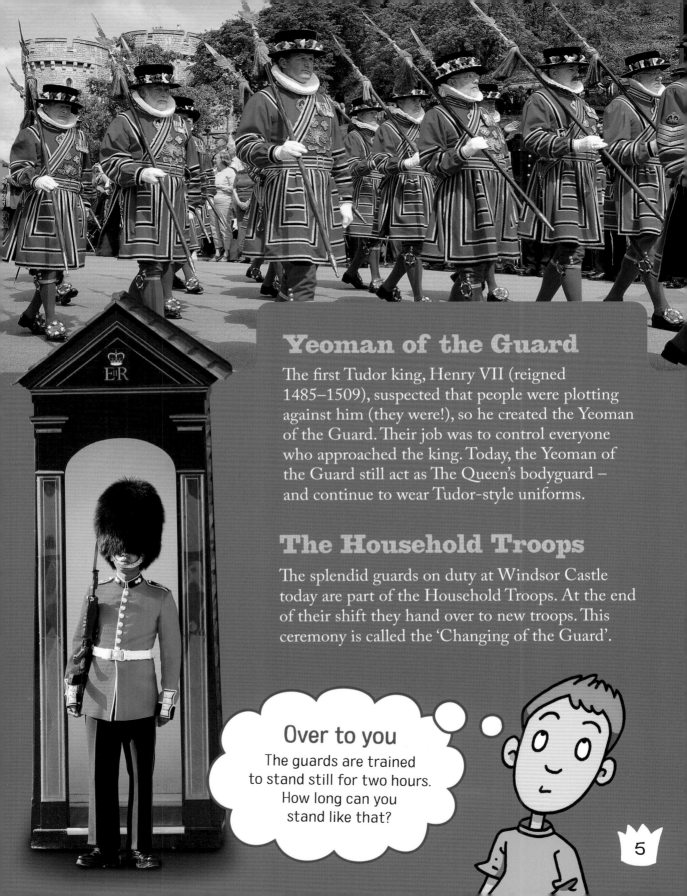

Yeoman of the Guard

The first Tudor king, Henry VII (reigned 1485–1509), suspected that people were plotting against him (they were!), so he created the Yeoman of the Guard. Their job was to control everyone who approached the king. Today, the Yeoman of the Guard still act as The Queen's bodyguard – and continue to wear Tudor-style uniforms.

The Household Troops

The splendid guards on duty at Windsor Castle today are part of the Household Troops. At the end of their shift they hand over to new troops. This ceremony is called the 'Changing of the Guard'.

Over to you

The guards are trained to stand still for two hours. How long can you stand like that?

Magnificent Knights

Edward III (reigned 1327–77) was born in Windsor Castle in 1312 and became king when he was a teenager. Tall and handsome with red-gold hair, Edward was a warrior king. He spent millions (in today's money) transforming the old fortress into a royal palace.

Knights of the Garter

In 1348 Edward created 26 Knights of the Garter, including himself and his son, known as the Black Prince. Inspired by the legend of King Arthur and the Knights of the Round Table, these young and courageous Garter Knights obeyed strict rules of bravery, loyalty and honour (called chivalry).

Edward's six-foot-long sword.

Edward chose St George to guard over his knights.

Team spirit

Edward's newly rebuilt palace provided a splendid place for great feasts and jousts (mock fights on horseback). Jousts were like football matches today, with team colours, noisy chants and even managers!

Practising for battle

Knights charged at each other and tried to score a strike with a long pointed pole (called a lance) which was designed to break when it hit an opponent. A shattered lance proved a direct hit. It was good practice for battles!

Come on the reds!

Secret signs

Knights could be badly wounded or killed in jousts so competitors wore armour to protect themselves. As they were invisible behind their helmets, signs were painted on to shields and banners so that they could be easily identified from a distance.

The three lions still appear on England's football kit.

Edward III's shield.

7

Beasts and Feasts

Hunting was the top sport of kings and queens so Windsor Castle was built close to a forest where plenty of deer and wild boar roamed. Forest Law said that only royalty and invited nobles could hunt there. Cruel punishments were handed out to anyone caught breaking the law.

Roast boar's head. Yum!

A huntin' we will go

Many kings and queens hunted as often as they could. Henry VIII (reigned 1509–47), who was a great sportsman when he was young, hunted every day except on holy days. His first two wives, Katherine of Aragon and Anne Boleyn, often accompanied him. Henry's daughter, Princess Elizabeth (later Elizabeth I, reigned 1558–1603), loved the chase too.

The castle kitchens were built by Edward III more than 600 years ago. They are still in use today.

Meat for the kitchens

The hunt provided venison (deer) and boar to feed the hundreds of people who worked or lived in the castle. Meat wasn't eaten on Fridays, some Wednesdays and during Lent for religious reasons. The court ate plenty of fish too, which came from the river, markets and the castle ponds.

State banquets

Kings and queens loved to show off their wealth and power by putting on great feasts. Today banquets are still part of the state visits made by very important people, such as rulers of other countries. The Queen personally inspects the menu and the table after it is laid.

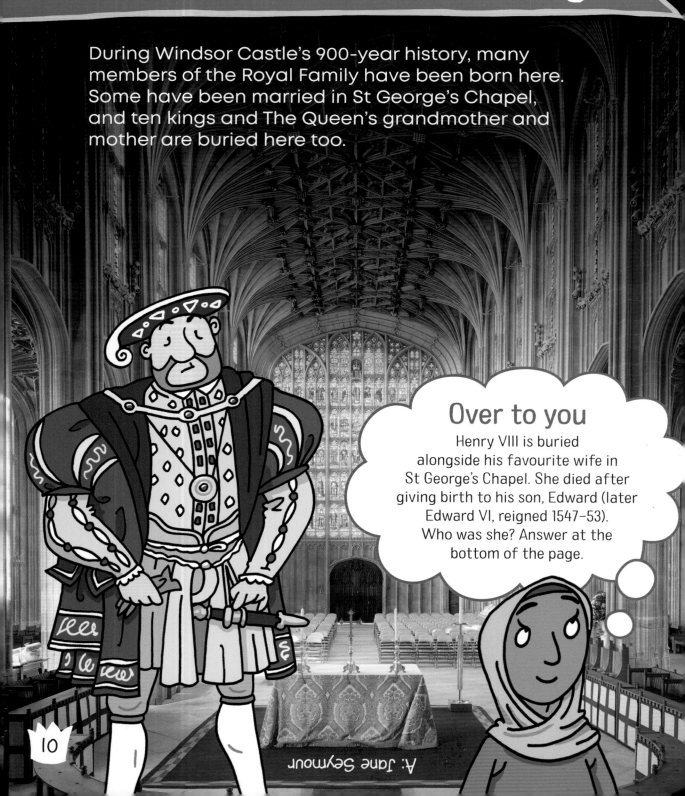

Births, Deaths and Marriages

During Windsor Castle's 900-year history, many members of the Royal Family have been born here. Some have been married in St George's Chapel, and ten kings and The Queen's grandmother and mother are buried here too.

Over to you

Henry VIII is buried alongside his favourite wife in St George's Chapel. She died after giving birth to his son, Edward (later Edward VI, reigned 1547–53). Who was she? Answer at the bottom of the page.

A: Jane Seymour

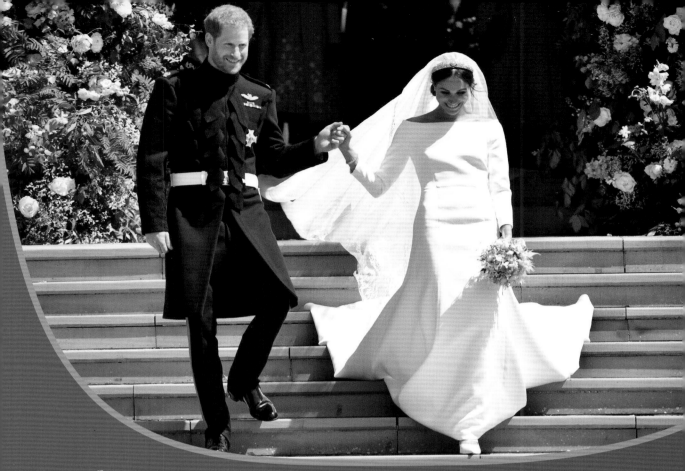

Royal weddings

Many royal marriages have taken place in St George's Chapel. In 1365 Edward III's daughter Isabella married a French nobleman, Enguerrand de Coucy. The king spent HUGE sums on jewels and silver. In 2018, on a beautiful sunny day, Prince Harry married Meghan Markle. After their wedding, Prince Harry and Meghan rode through Windsor town in an open carriage so that as many well-wishers as possible could see them and join in the celebrations. Later that year Princess Eugenie married Jack Brooksbank. They also travelled through the town but this time in a closed carriage to protect them from the weather.

Thrown in Prison!

Medieval castles were often used to hold prisoners. Rebels could be left in dungeons to rot but some foreign kings and nobles lived there in great comfort.

In the Middle Ages kings and nobles were sometimes captured in battle and kept prisoner until VAST sums of money (called ransoms) were paid for their release. During Edward III's reign, King David II of Scotland and King John of France were held at Windsor Castle. They were both treated well – and even went hunting with Edward.

Did you know?

The 'Poor Knights' fought for Edward III in France. They were captured and had to sell their lands to pay the ransoms, so the king allowed them to live in Windsor Castle. Today the Military Knights (as they are now known) are retired army officers and still live in houses opposite St George's Chapel.

The Civil War

When Charles I was king (reigned 1625–49), he fell out with Parliament and finally, in 1642, a Civil War was declared between the king (whose supporters were called Royalists) and Parliamentarians led by Oliver Cromwell. Windsor Castle became a base for Parliamentarians and high-ranking Royalist soldiers were imprisoned here in comfortable conditions. But lower-ranking prisoners were thrown into stinking dungeons and fed on mouldy bread and water.

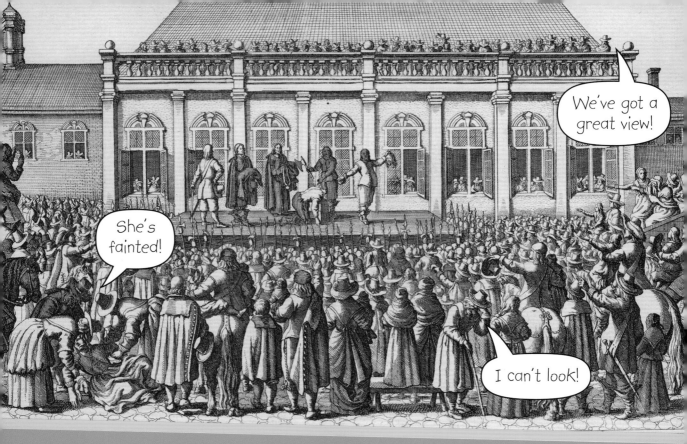

Beheaded

In 1649 Charles I was condemned to death. The king spent his last Christmas at the castle before being taken to London and executed. His body was brought back to Windsor and buried in St George's Chapel – with his head reattached to his body.

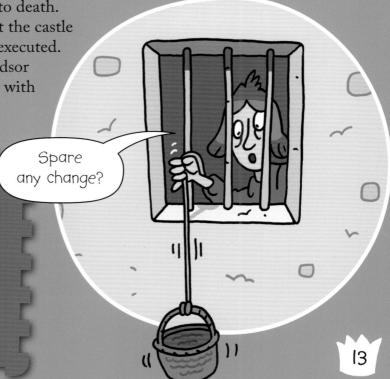

Money for food

In the 1700s there was a debtors' prison (for people who owed money) above the Henry VIII Gate. Prisoners had to pay for their own food so they dangled baskets out of their cell windows to beg for money.

Priceless!

Every king and queen for the last 500 years has added to the treasures at Windsor Castle. Now it is one of the world's greatest collections of paintings, books, china, silver and furniture.

Psst! The King was only five feet tall!

Sir Anthony van Dyck painted flattering portraits of rich and famous people. This ENORMOUS picture, painted in 1633, shows Charles I in armour on a magnificent white horse entering through an arch in triumph.

Sold off!

Once the Civil War was over Oliver Cromwell (Lord Protector 1653–8) ordered a lot of the royal treasure, including Charles I's collection of 1,500 paintings and 500 sculptures, to be sold off.

After Cromwell died, Charles I's eldest son and heir, Prince Charles, returned from exile in France and was crowned Charles II. By this time, the castle was looking very shabby as it had not been cared for during Cromwell's rule.

Loving luxury

Charles II (reigned 1660–85), who had grown used to French luxuries, appointed the best architect, craftspeople and artists to redecorate Windsor Castle in a very fashionable, highly decorated style (called baroque). He knew that beauty and splendour made him look AWESOME!

Gorgeous!

This silver mirror belonged to Charles II.

Over to you

Can you spot

- Seigneur de St Antoine, the king's French riding master?
- The silk curtain? Van Dyck loved painting rich fabric.

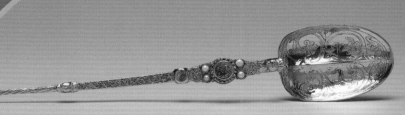

Charles II set about getting back all the treasures that had been sold off. The Coronation Spoon is the oldest of the Crown Jewels. It was sold in 1649 but returned in time for Charles II's coronation ceremony.

Devastation!

Windsor Castle was attacked in 1216 and during the Second World War it was in danger of being bombed. But one of the biggest disasters in its history was the terrible fire of November 1992.

Fire!

The fire started in a private chapel and raced through the old timber roof with frightening speed. By the time fire engines had arrived, the north-east corner of the castle was burning fiercely. All the firefighters could do was to stop the flames spreading further.

Did you know?

A two-tonne urn was too heavy to move. It was filled with water as firefighters hosed the room, and all the pieces of semi-precious stone which covered its surface popped off!

Thirty-nine fire engines sped to the castle and 250 firefighters fought to control the blaze.

In ruins

Everyone in the castle formed a human chain to rescue priceless works of art. Incredibly, very few were destroyed – but 115 rooms were gutted and the fire caused many millions of pounds' worth of damage.

The roof of St George's Hall was badly damaged.

Repairing the damage

Restoring everything to its former glory involved carpenters, upholsterers, painters, gilders and many, many more craftspeople. It took five years to complete and afterwards The Queen and The Duke of Edinburgh held a party for everyone who had helped.

Power and Glory

George III was crowned king in 1760 and ruled for 60 years. During much of that time Britain was at war with France, then the most powerful country in Europe.

Heroes and villains

Napoleon Bonaparte, an outstanding and ambitious general in the French army, wanted to rule all of Europe – including Britain! Admiral Lord Nelson was one of Britain's greatest naval commanders. He won the Battle of Trafalgar in 1805, defeating Napoleon's navies at sea. In 1815 the Duke of Wellington, a brilliant general in the British army, defeated Napoleon at the Battle of Waterloo.

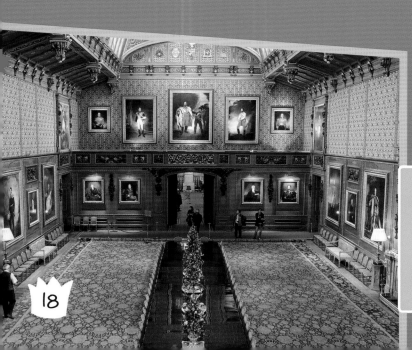

George IV (reigned 1820–30) built the Waterloo Chamber to celebrate victory over Napoleon. It's decorated with portraits of all the European leaders who had helped to defeat the French.

The castle on the hill

When George IV came to the throne, Britain was becoming increasingly powerful and the king wanted Windsor Castle to look more impressive so he had the Round Tower and the castle walls raised, and the gates made grander. This is the castle you see today.

King of bling

Inside the castle, George IV had rooms decorated with plenty of gold. People joked that if something moved he would have it covered in gold! He spent a fortune on the best French furniture, priceless paintings and expensive objects. It's these works of art which help make the Royal Collection so important today.

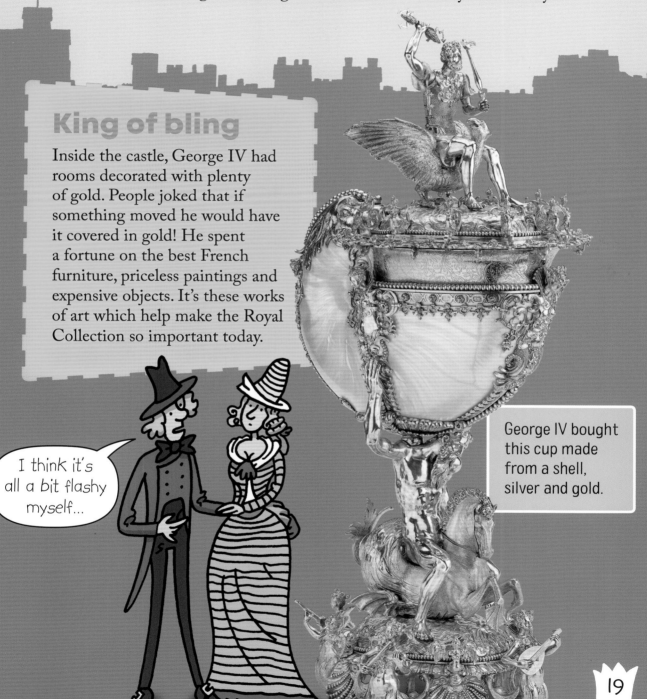

> I think it's all a bit flashy myself...

George IV bought this cup made from a shell, silver and gold.

A Family Home

Queen Victoria (reigned 1837–1901) proposed to Prince Albert of Saxe-Coburg-Gotha at Windsor in 1839. After they married, they decided to make the castle their main family home.

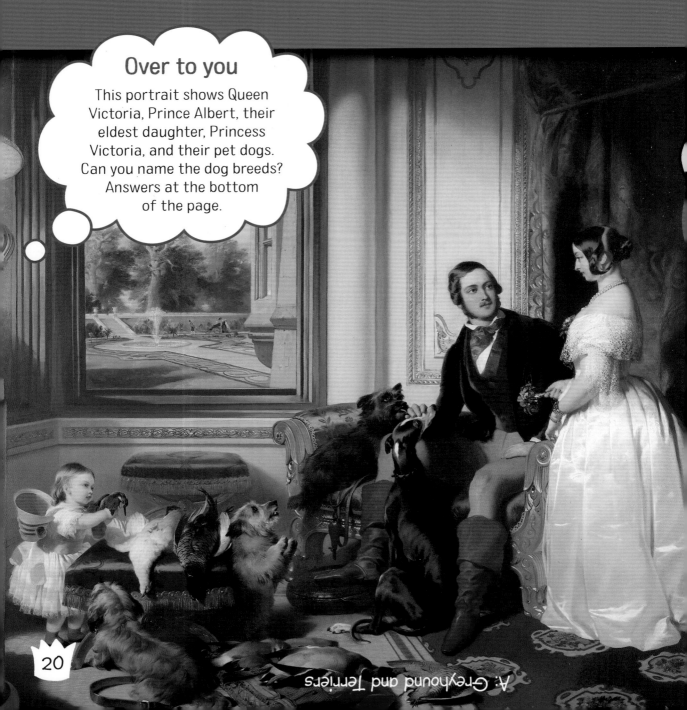

Over to you

This portrait shows Queen Victoria, Prince Albert, their eldest daughter, Princess Victoria, and their pet dogs. Can you name the dog breeds? Answers at the bottom of the page.

A: Greyhound and Terriers

Windsor in winter

Victoria and Albert liked to spend Christmas and New Year at Windsor Castle with their children. The Royal Family often spoke in German to each other and many of the Christmas traditions we have today came from Germany. Victoria and Albert invited important people to Windsor for sleepovers. What a treat! Or was it? Some guests complained that the castle was FREEZING and so big that they got lost on the way back to their rooms.

The Queen's Christmas tree at Windsor.

The royal train

The railway came to Windsor town in 1849 and the Royal Family were soon using it regularly. Queen Victoria insisted that the steam train should go no faster than 40mph during the day and 30mph at night. Meanwhile, the railway allowed more people to visit the castle.

My horse goes faster than that train!

Growing Up at Windsor

Princess Elizabeth (now Queen Elizabeth II) and her younger sister Princess Margaret both grew up and were educated at Windsor Castle.

Windsor in wartime

During the Second World War the young Princesses remained at the castle for safety. Their parents, King George VI (reigned 1936–52) and Queen Elizabeth, stayed at Buckingham Palace during the week and returned to Windsor at weekends.

Like ordinary homes, all the castle windows were fitted with blackout blinds to make navigation by enemy aircraft difficult at night. Basement rooms were converted into air-raid shelters in case the castle was bombed.

The most precious jewels were hidden in a biscuit tin and stored in a tunnel beneath the castle!

This'll fool them!

This will cheer things up.

During the war, the portraits in the Waterloo Chamber were removed for safety and the empty spaces filled with pictures of pantomime figures painted by a young evacuee. They are still there, hidden behind the paintings!

Fun at Christmas

Both the young princesses loved acting and performed in plays and pantomimes on a temporary stage set up in the Waterloo Chamber. Children and teachers from the Royal School in Windsor took part in the productions.

Over to you

Princess Elizabeth had two pet corgis called Dookie and Jane. She and Princess Margaret also had three labradors called Mimsy, Stiffy and Scrummy. Do you have pets? What are they called?

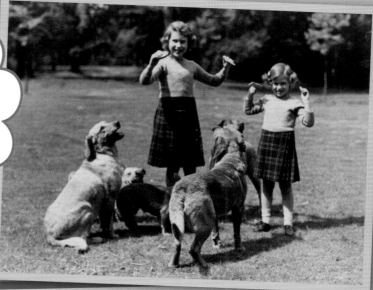

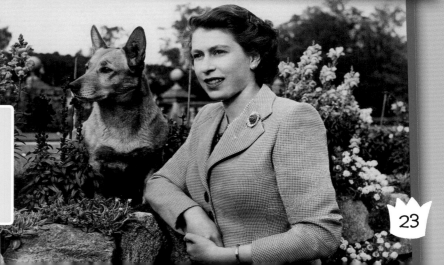

On her 18th birthday Princess Elizabeth was given a corgi called Susan. All the corgis since bred by The Queen are descended from Susan.

Mini Me

One of the most popular attractions at Windsor Castle is the dolls' house given to The Queen's grandmother, Queen Mary, in 1924. It is the largest and most famous dolls' house in the world. But it isn't a toy.

All mod cons

Queen Mary loved collecting pretty things, especially miniature objects. She was presented with this fabulous dolls' house, made to show off the best of British craftsmanship. It has electricity, hot and cold running water, two lifts and even flushing lavatories.

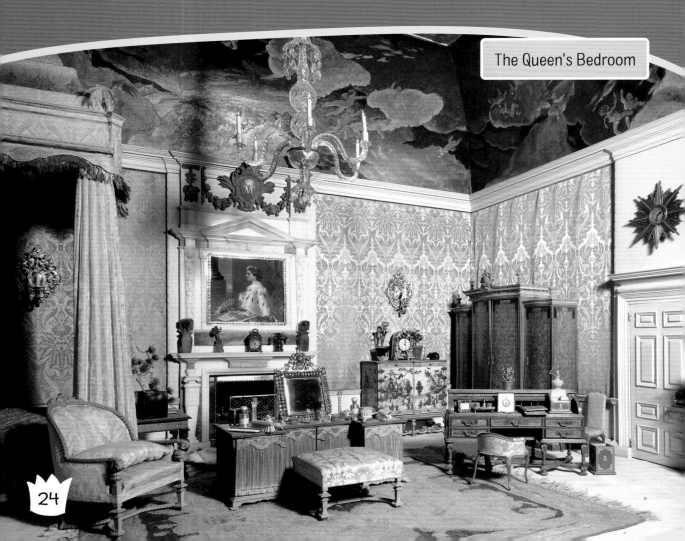

The Queen's Bedroom

24

Made to scale

The dolls' house was designed by Sir Edwin Lutyens, a famous architect. Well-known artists, designers, writers, composers, craftspeople and manufacturers worked together to fill it with everything a real king and queen would need – but in miniature.

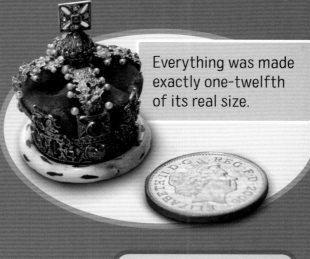

Everything was made exactly one-twelfth of its real size.

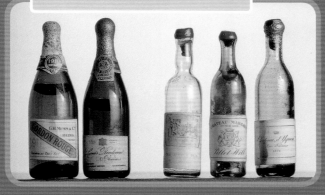

These bottles are filled with real champagne and wine.

This teeny letter rack holds writing paper and envelopes.

A mouse with real diamond eyes is in the Queen's Bedroom! Can you spot it?

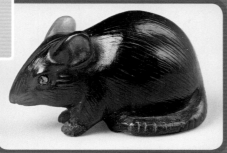

Mini jars of sweets, tins of biscuits and boxes of chocolates were made for the Day Nursery.

Even kings and queens need to wash their hands. Can you spot the tiny bar of soap?

The Great Park

The Great Park which surrounds Windsor Castle was once part of a larger royal hunting ground. In the past it was strictly off-limits to anyone else, but today some parts are open to the public.

From the 1700s onwards, kings preferred shooting to hunting. Over time the Great Park was made into gardens with woodland glades, lakes and small buildings where they could relax away from the strict rules of castle life.

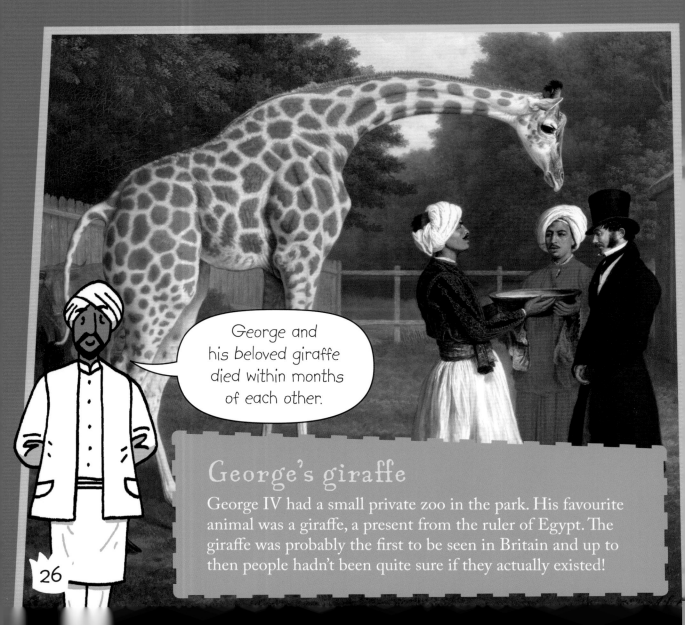

George and his beloved giraffe died within months of each other.

George's giraffe

George IV had a small private zoo in the park. His favourite animal was a giraffe, a present from the ruler of Egypt. The giraffe was probably the first to be seen in Britain and up to then people hadn't been quite sure if they actually existed!

Albert's farm and dairy

Prince Albert was very interested in new methods of farming. He set up modern farms to supply the castle with fruit and vegetables. In 1869 16,800 bunches of carrots, 3,670 kilos of potatoes and 13,800 stalks of asparagus were delivered to the kitchens, along with artichokes, rhubarb, cucumbers, endives, lettuces and radishes.

There is still a Windsor Dairy Farm with a herd of Jersey cows. Many of them are descended from those given to Queen Victoria as a present.

Horses for courses

The Queen is very knowledgeable about horses and is an excellent horsewoman. She, and other members of the Royal Family, keep their own horses at Windsor. The annual Royal Windsor Horse Show, polo matches and horse carriage-riding events take place here too.

A Working Palace

Windsor Castle has over a thousand rooms. More than a million tourists visit it every year and it is home to more than 160 people. Managing it is an ENORMOUS task.

Castle control

In Norman times a Constable looked after the castle when the king or queen wasn't here. Today a Constable (also called the Governor) still looks after the castle on behalf of The Queen. During the Middles Ages, the castle was like a great beehive, with hundreds of people living and working there. The most important people were ministers and churchmen who helped to run the country. Hundreds of servants, mostly boys and men, were responsible for feeding everyone twice a day, and craftspeople such as blacksmiths, stonemasons and carpenters looked after the buildings.

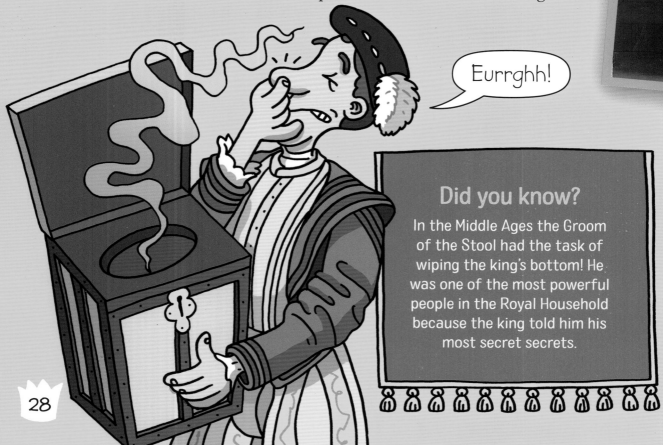

Eurrghh!

Did you know?

In the Middle Ages the Groom of the Stool had the task of wiping the king's bottom! He was one of the most powerful people in the Royal Household because the king told him his most secret secrets.

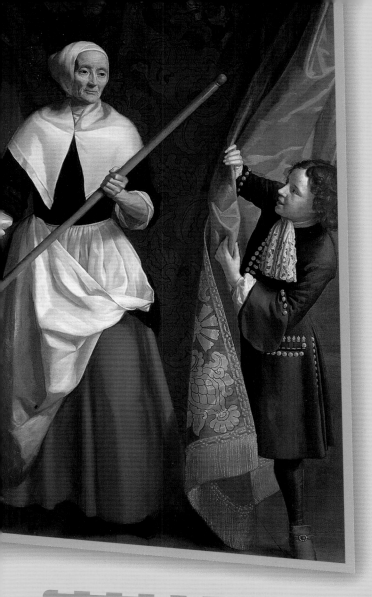

Bridget Holmes

This is Bridget Holmes who cleaned the royal bedchamber, laid fires, mopped floors and emptied the 'necessaries' (chamber pots) for James II (reigned 1685–8).

Pictures of servants are very rare and it may have been painted because she had served four kings: Charles I, Charles II, James II and William III. Or maybe because she was 96 years old (she lived to the age of 100!) – and still cleaning!

Out of sight

Bridget was one of the army of servants who did all the dirty tasks in the 1700s. They were kept well out of sight of the noblemen and women who attended the king and queen.

Upstairs and downstairs

When Victoria became queen, the Royal Household was badly organised. For example, when the Queen asked the servants attending her why there was no fire, she was told they could lay it, but another department had to light it. Prince Albert decided to change things. There are fewer domestic staff today but Albert's system is still in place.

Famous Faces

Windsor Castle is one of The Queen's four official homes where she welcomes kings, queens and important guests from across the world.

Garter Day

Every year, like Edward III more than 600 years ago, The Queen leads Garter Knights (and now Ladies of the Garter too) to a service in St George's Chapel and then to a grand meal in St George's Hall. The Queen is Head of the Order and chooses all the Knights. Just as Edward appointed his eldest son to the Order, so The Queen has chosen her eldest son, Prince Charles. Other Knights are members of the Royal Family, and people who have played a big part in national life such as past prime ministers.

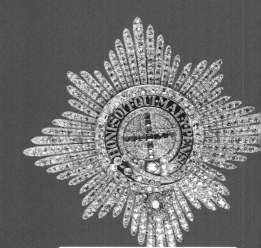

The Garter Star is the badge of the Knights of the Garter.

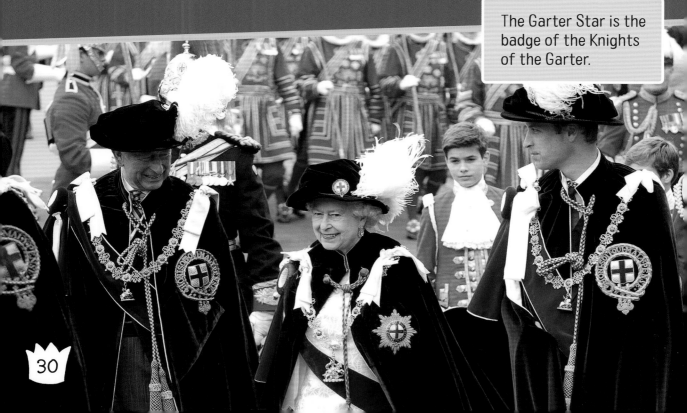

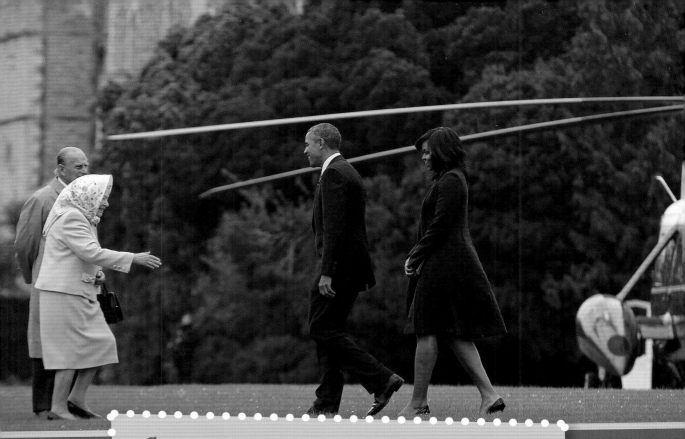

Starry guests

The Queen has welcomed many famous people to Windsor Castle, including the former President of the USA, Barack Obama, and his wife Michelle, the British astronaut Tim Peake and actor Daniel Craig.

Special events

Sometimes other members of the Royal Family hold special events at Windsor Castle. Prince William hosted a charity gala at the castle, to which guests such as *Harry Potter* star Emma Watson, models Kate Moss and Cara Delevingne, and singer Emeli Sande were invited.

What Happened When

1066
William the Conqueror invades England

1216
King John's enemies besiege the castle

1346
Edward III transforms the old castle into a palace

About 1070
William builds Windsor Castle

1939–45
Second World War

1914–18
First World War

1952
Elizabeth II becomes Queen

1992
Fire destroys part of Windsor Castle

2012
Queen Elizabeth II's Diamond Jubilee

2018
Prince Harry marries Meghan Markle; Princess Eugenie marries Jack Brooksbank in St George's Chapel

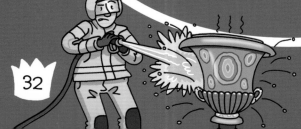